Mount Rainier

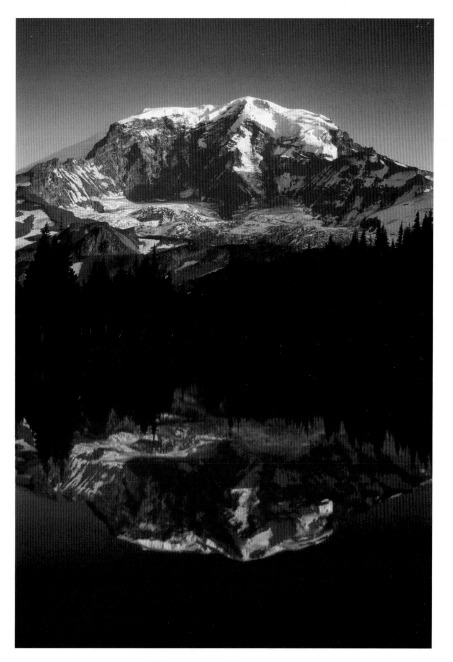

Don Geyer

Good luck in your
photography aspirations!

Don Geyer

hancock
house

ISBN 0-88839-597-3
Copyright © 2005 Don Geyer

Cataloging in Publication Data
Geyer, Don, 1967–
 Mount Rainier / photography and text by Don Geyer.

ISBN 0-88839-597-3

 1. Mount Rainier National Park (Wash.)—Pictorial works. 2. Rainier, Mount
(Wash.)—Pictorial works. 3. Nature photography—Washington (State—Mount Rainier
National Park. 4. Landscape photography—Washington (State)—Mount Rainier
National Park. I. Title.

F897.R2G49 2005 917.97'782'002 C2005-900145-3

Editing: Ingrid Luters
Production: Ingrid Luters, Rick Groenheyde, Laura Michaels
Cover design: Rick Groenheyde
Printed in South Korea: PACOM/SUNGIN

Published simultaneously in Canada and the United States by

HANCOCK HOUSE PUBLISHERS LTD.
19313 Zero Avenue, Surrey, B.C. Canada V3S 9R9
HANCOCK HOUSE PUBLISHERS
1431 Harrison Avenue, Blaine, WA USA 98230-5005
(604) 538-1114 Fax (604) 538-2262
(800) 938-1114 Fax (800) 983-2262
Website: www.hancockhouse.com *Email:* sales@hancockhouse.com

Contents

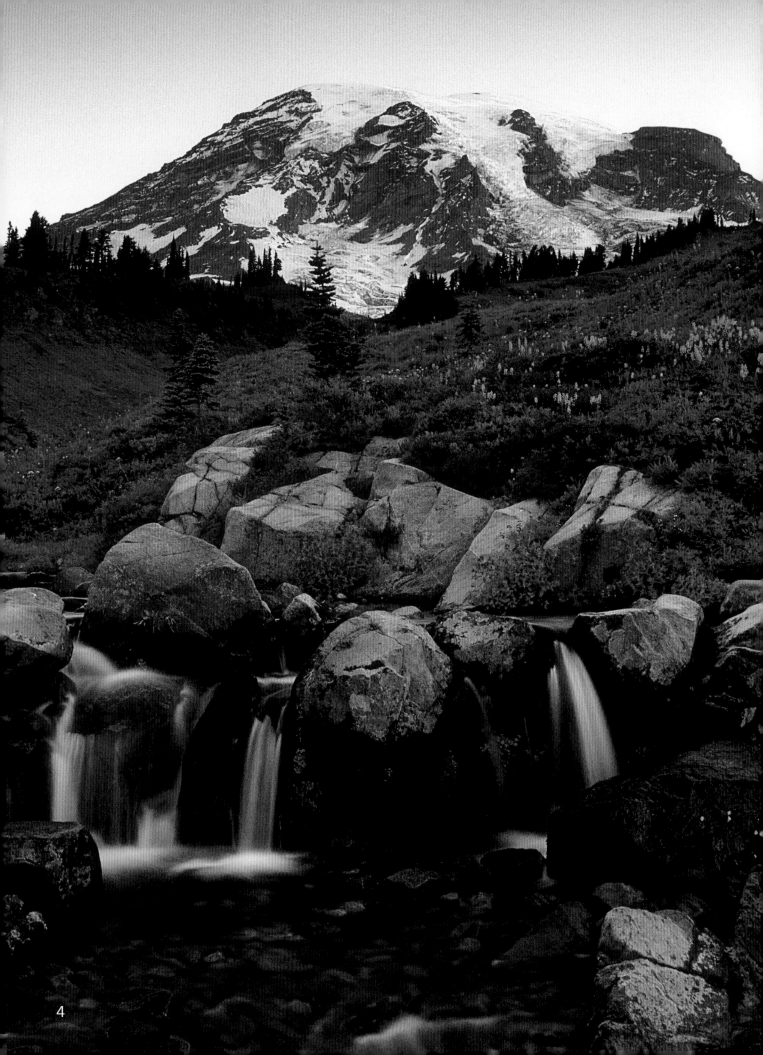

Introduction

Mount Rainier National Park is easily the most diverse national park in North America. Beginning with a very unusual inland temperate rainforest at just over 1,700 feet to the summit of its spectacular namesake volcano at 14,411 feet, the park is home to many life zones and an array of vegetation and geological features.

Mount Rainier's lowland forests must even be subclassified. The southeast corner of the park contains evergreens that rival the redwoods of California. The Grove of the Patriarchs near the Stevens Canyon entrance includes old growth Douglas fir, western hemlock and western red cedar. Some of these trees have diameters in excess of 8 feet and tower over 200 feet tall.

Meanwhile, in the northwest corner of the park the Carbon River valley is home to a temperate rainforest that more closely resembles those found along the Pacific coastline. Sitka spruce, nurse logs and an abundance of moss and ferns dominate this side of the park. Heavy rainfall and the common occurrence of summer fog play a large role in this life zone.

The silver fir forest is the most common and well-recognized forest within the park. It begins at about 2,200 feet where the Pacific silver fir is the most dominant tree. It shares the forest with the noble fir near this elevation, while its upper reaches, near 4,500 feet, are dominated by the yellow cedar, mountain hemlock and silver fir. These species flourish despite the constant rigors of altitude, cold temperatures, drought, wind and a shorter growing season.

The next life zone is the subalpine zone. This zone stretches from about 4,500 feet to the growing limits of the trees. Islands of trees and open meadows characterize this zone. Subalpine fir, silver fir, mountain hemlock and yellow cedar cluster to survive the elements here. This zone produces some of the best wildflower shows for photography.

The alpine zone exists above tree line and consists of a world of rock and ice. Heather, lupine and other adaptive plants still find a way to exist despite the harsh environment and weather extremes. The ceiling for plants is at about 9,000 feet. Above this, only algae and lichen continue to exist.

Mount Rainier National Park is truly a playground for photographers. The park consists of 235,625 acres (97 percent is designated as federally protected wilderness), encompasses elevations from 1,610 to 14,411 feet, includes 9 major watersheds, 382

Front cover: Evening alpenglow on Mount Rainier from Tolmie Peak.

Title page: Evening light on Mount Rainier and the Willis Wall reflected in a tarn above Mystic Lake.

Opposite page: Early light on Mount Rainier above Edith Creek and Paradise Meadows.

lakes, 470 streams and rivers, 787 plant species, 126 bird species and 54 mammal species. Nearly all sides of Mount Rainier can be viewed from a road. The mountain benefits from both morning and evening light, which is quite uncommon for most comparable subject matter.

Photographers have certainly established their favorite destinations within the park — and it should be of no surprise with nearly two million visitors annually. Reflection Lakes probably top the popularity list, with Paradise Meadows not far behind. Show up to either of these destinations on a summer morning and you will find photographers lined up side by side by side, or even waiting in line for specific compositions! Still, they come back again and again for the experience.

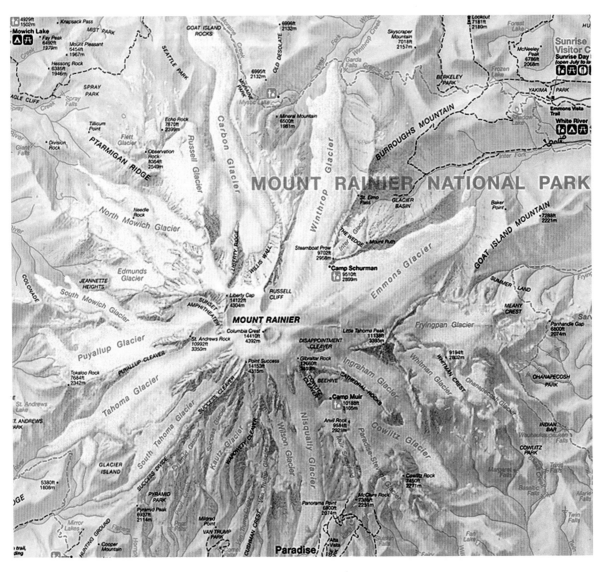

Map of Mount Rainier.

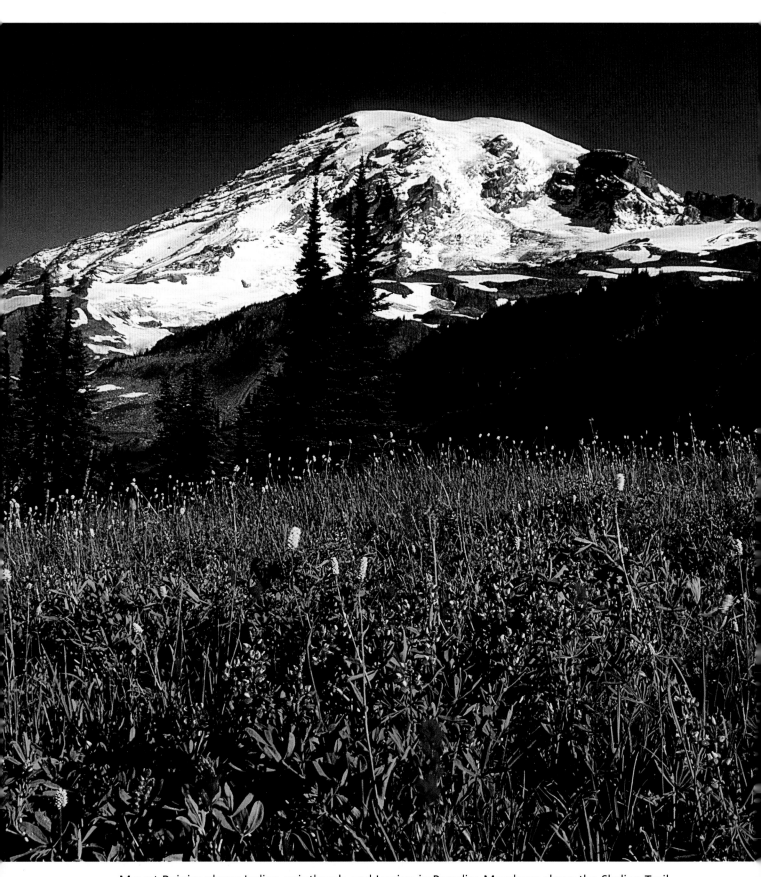

Mount Rainier above Indian paintbrush and Lupine in Paradise Meadows along the Skyline Trail.

Spring

Spring offers an excellent time to photograph foliage, streams and waterfalls in the park before the droves of summer visitors arrive. In fact, it is easy to find solitude on many trails during this time for uninterrupted photography.

With temperatures beginning to warm in April, the Carbon River Rain Forest turns a brilliant green with lush new growth in an already amazing setting. Ferns and mosses are abundant and are best enjoyed and photographed on overcast days with a light drizzle. Rain droplets on the ferns reflect the ambient light and also add mood to the setting. Your greens will jump right out of your image with a polarizer.

The Carbon River Valley is a rare example of an inland temperate forest and will remind many of the rainforests on the Olympic coast. This beautiful valley displays nurse logs, moss-draped trees and an abundance of ferns, soft moss-carpeted ground and many other classic examples of a rainforest.

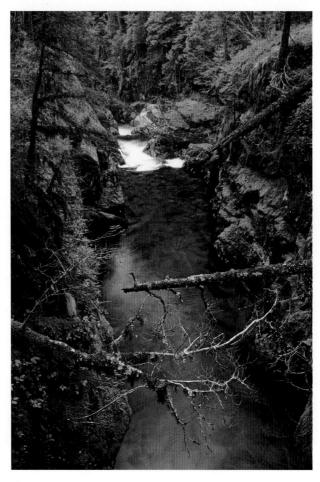

The Ohanapecosh River rages through a gorge below Silver Falls.

The forest canopy keeps the light level low on the forest floor where shade flowers dwell.

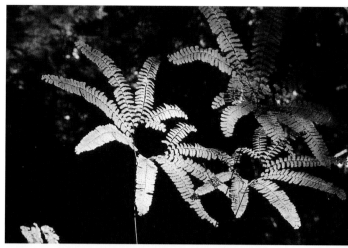

Ferns along the Green Lake trail in the Carbon River Rain Forest.

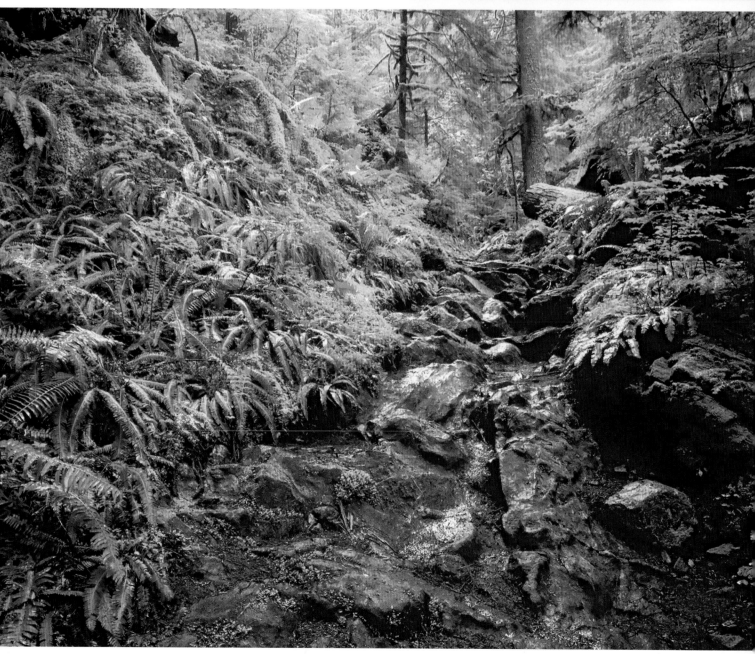

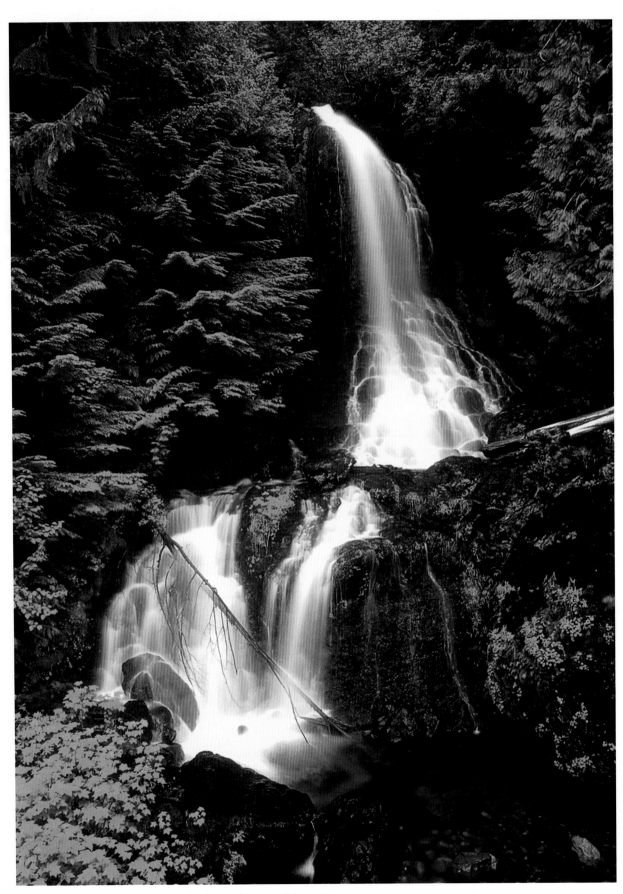

Waterfall along Chinook Creek along the Eastside trail.

The Green Lake trail is one of the best forest hikes in Mount Rainier National Park. Ferns and devil's club abound amongst groves of old growth trees while moss-covered tree overpasses along the trail offer excellent trail photography and serve as an excellent setting for photographing hikers.

The first three-quarter mile along the Carbon River trail is also excellent for intense patches of ferns and scenic views looking out over the forest below.

In late spring, the Eastside trail and Silver Falls area offer excellent opportunities to photograph waterfalls. The bonus to Silver Falls is the gorge immediately south of the trail bridge, spanning the Ohanapecosh River.

Inside the Stevens Canyon Entrance, Grove of the Patriarchs offers an excellent cloudy-day destination for photographing impressive thousand-year-old Douglas firs and western red cedars.

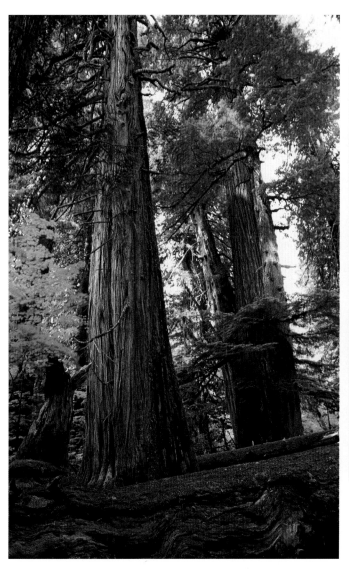

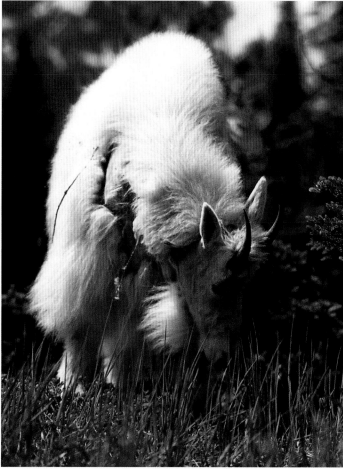

In spring mountain goats molt their heavy white fur.

Western red cedars in Grove of the Patriarchs.

Early Summer

Late July and early August produce intense flower displays in Mount Rainier National Park that rival all of Washington State. It's not a coincidence that this is peak tourist season.

The flower shows start in mid- to late July in most of the higher alpine meadows to the northwest and northeast sections of the park. Yakima Meadows at Sunrise can be accessed with short walks from the parking lot, the best being the easy Silver Forest trail. For those willing to sacrifice views of Rainier and have a little more ambition, Berkeley Park puts on an excellent showing along Lodi Creek.

Late July is also prime flower season at Spray Park, a favorite amongst hikers and flower enthusiasts. The compositions are endless due to the vast expanse of the park and the lush meadows and include many tarns to capture reflection shots as well.

For the overnight backpacker, Moraine Park is a popular destination in late July and offers incredible close-up views of Mount Rainier's Willis Wall, where avalanches constantly thunder down the mountain.

In early August the flower show shifts to the south side of Mount Rainier. Paradise Meadows is easily the most popular due to easy access and a network of short and mostly paved trails. Displays can be incredible in a good year and attract professional photographers from around the world. Don't expect to be alone on a weekend. In fact, visits during the week will be much more productive and less frustrating to the photographer looking for popular compositions. Last year on a Saturday morning I counted thirteen photographers with their tripod legs intertwined at the small crossing of Edith Creek trying to photograph the sunrise. For those willing to walk a modest distance, The Lakes trail via the Skyline trail is an excellent choice and far less crowded than above the Paradise parking lot.

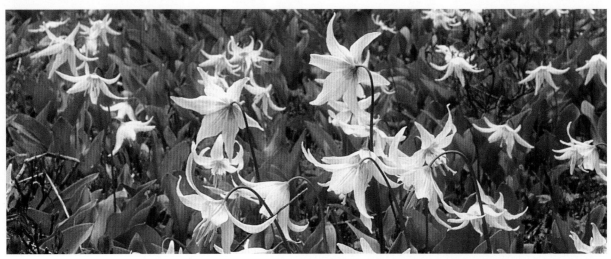

Above: Avalanche lilies above Lake George.

Opposite: Mount Rainier above a tarn in Spray Park.

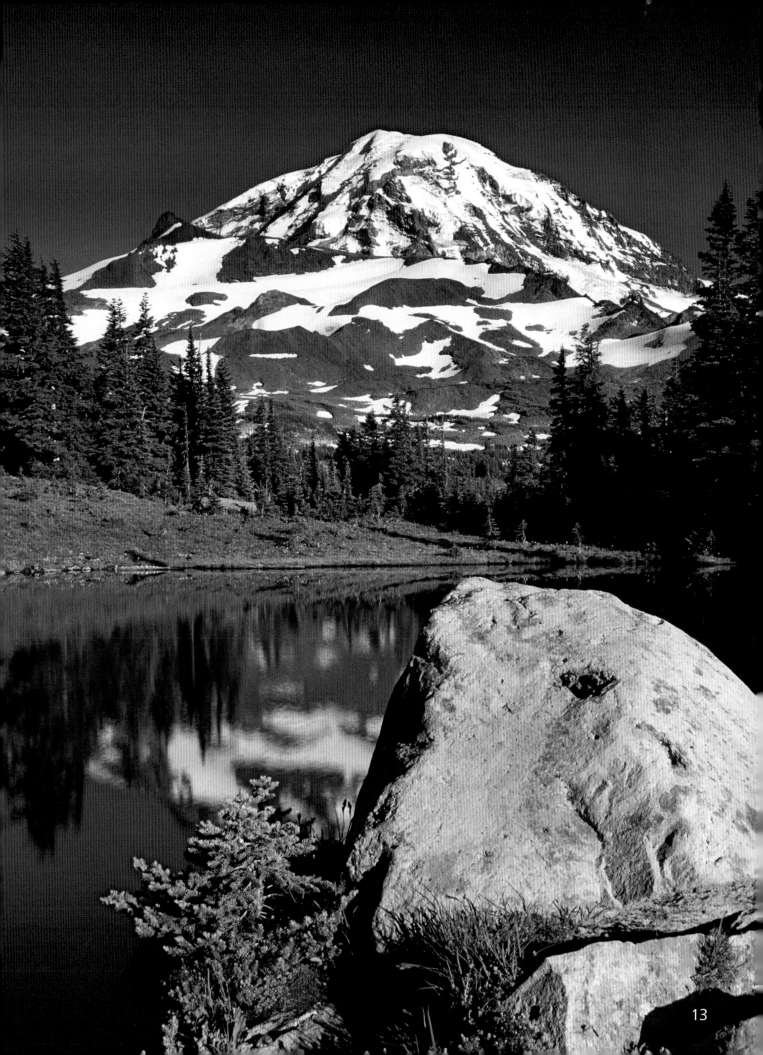

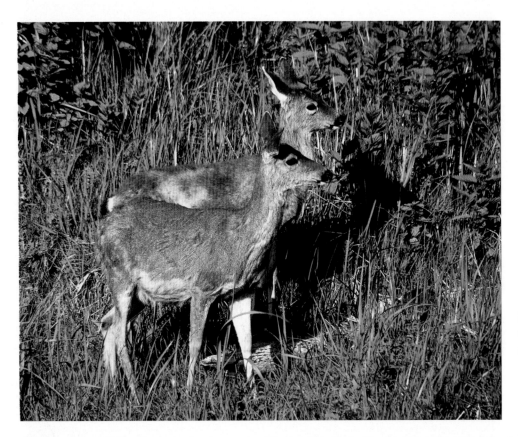

Left: Black-tailed deer alerted by a distant noise.

Below: Mount Rainier above lupine and paintbrush in Paradise Meadows along The Lakes trail.

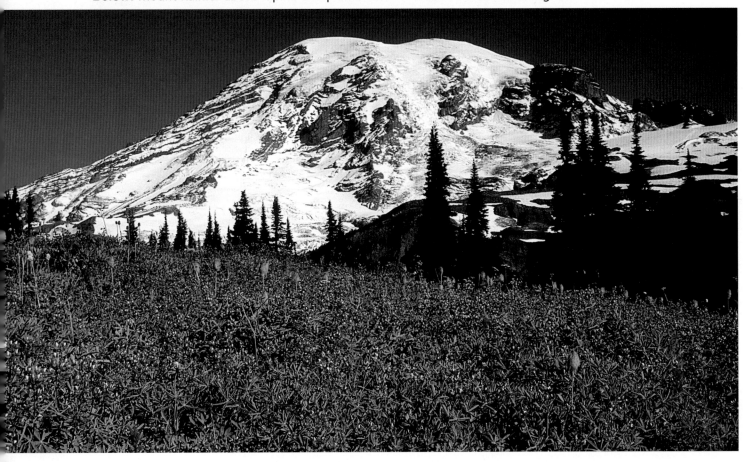

Opposite: Mount Rainier reflected in Reflection Lakes with elephant head in bloom.

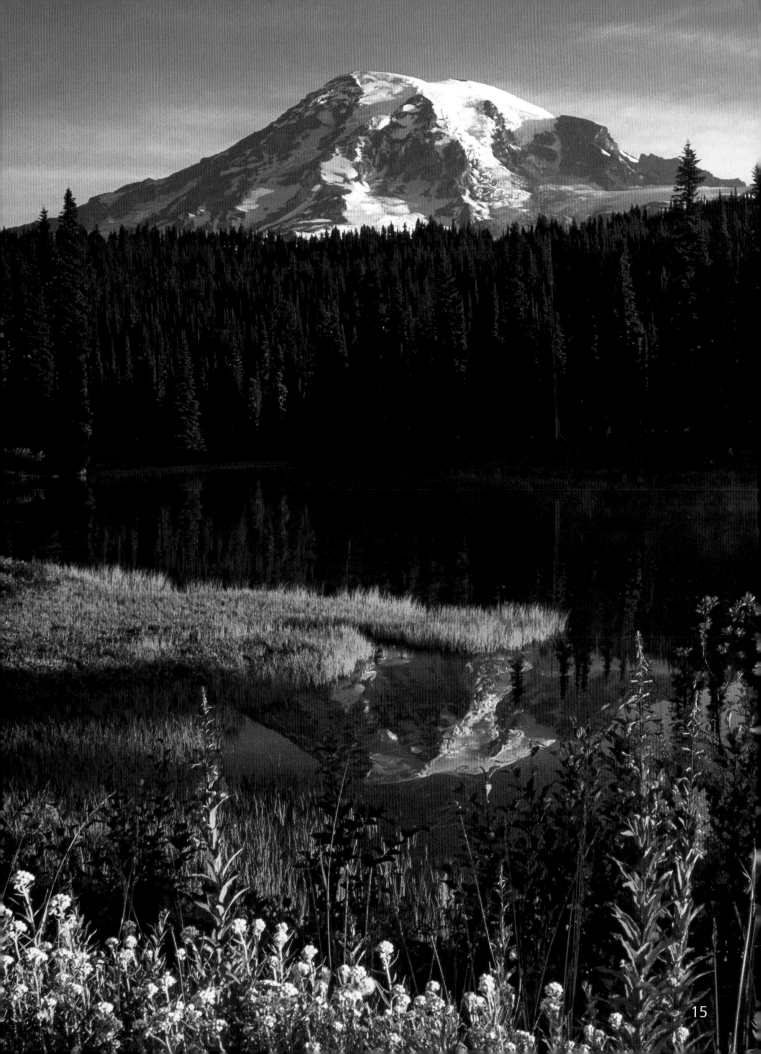

Below: Mount Rainier above meadows of lupine and Indian paintbrush in Spray Park.

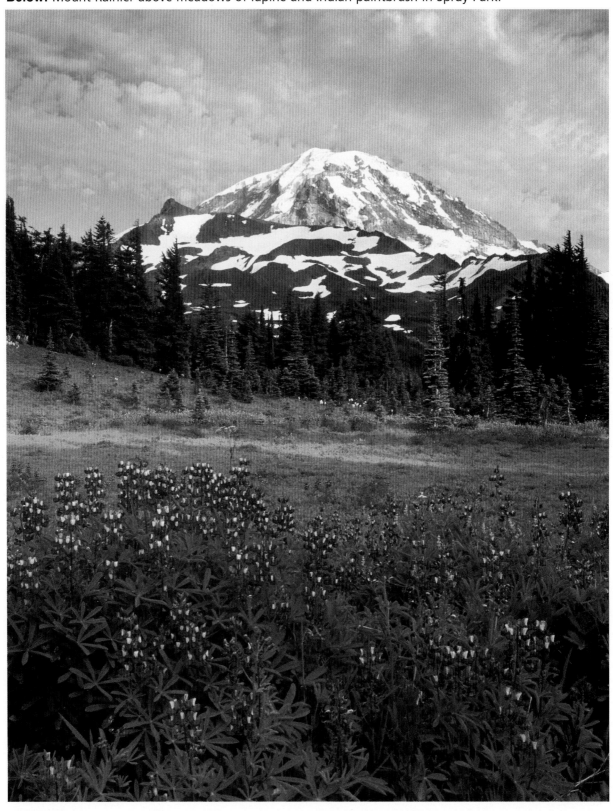

Opposite top: Paintbrush along The Lakes trail below Mount Rainier.

Opposite bottom: Monkey flower in bloom along the Paradise River near the Skyline trail.

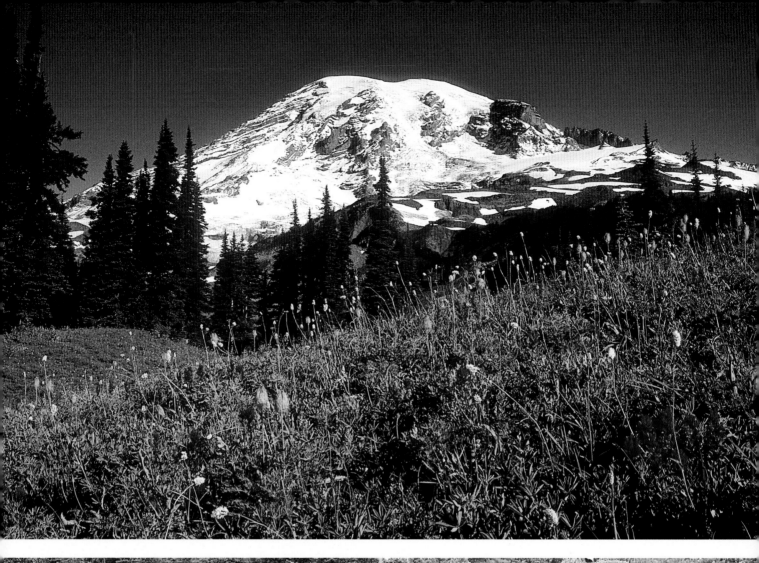

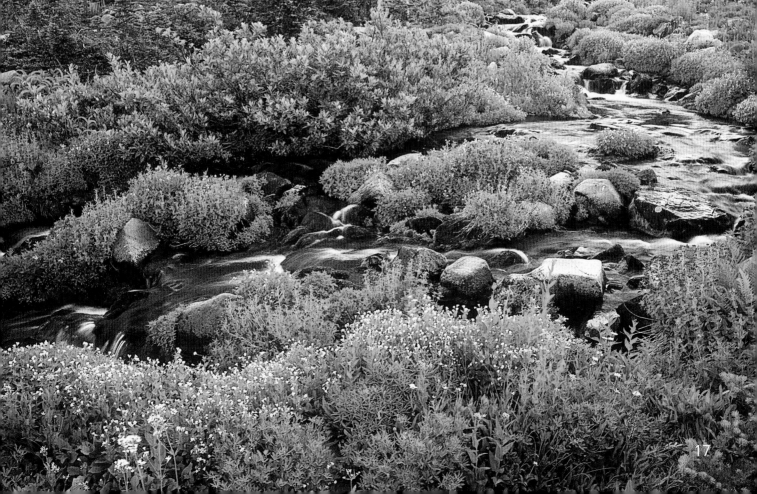

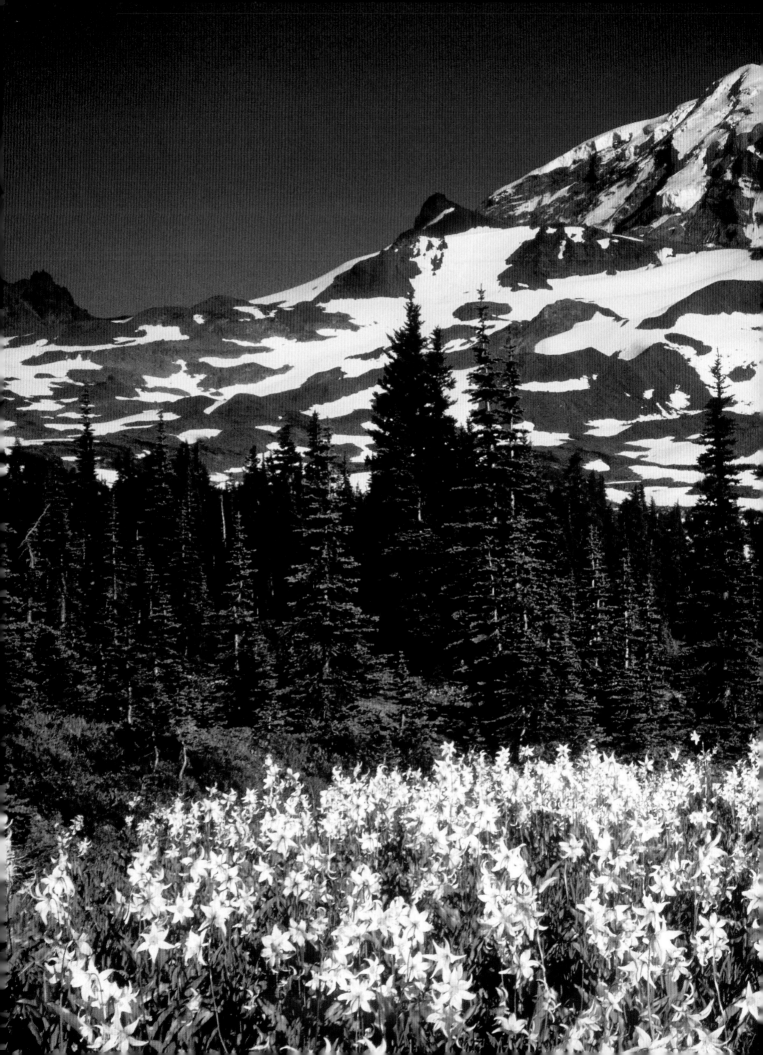

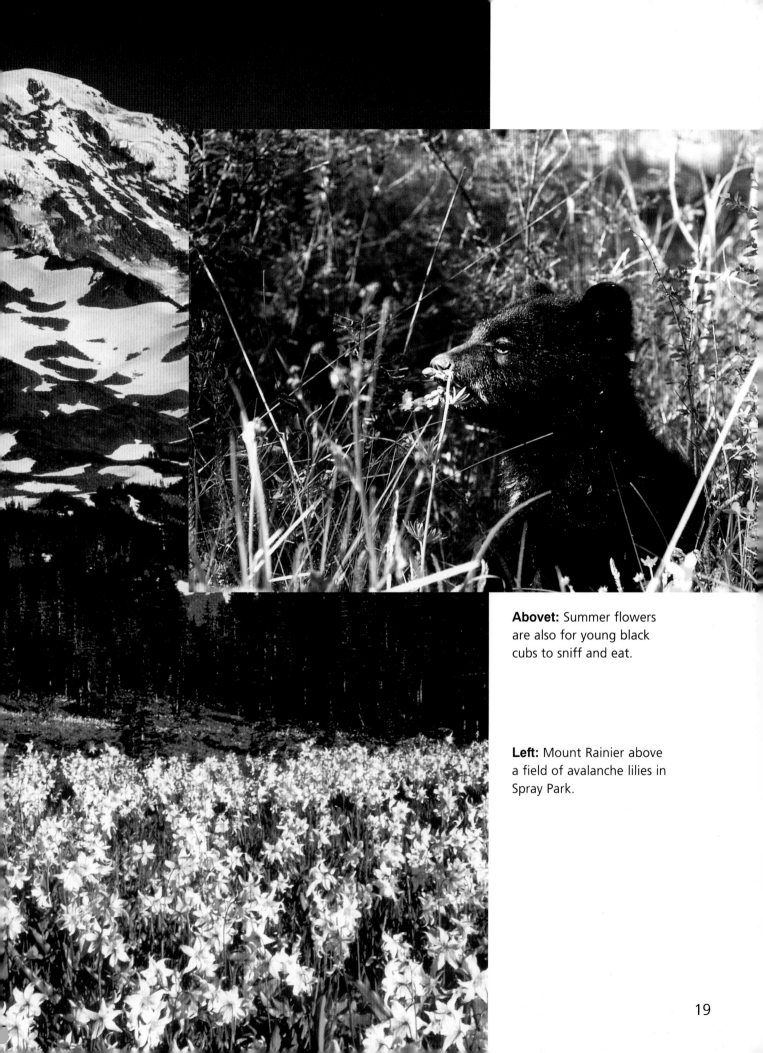

Abovet: Summer flowers
are also for young black
cubs to sniff and eat.

Left: Mount Rainier above
a field of avalanche lilies in
Spray Park.

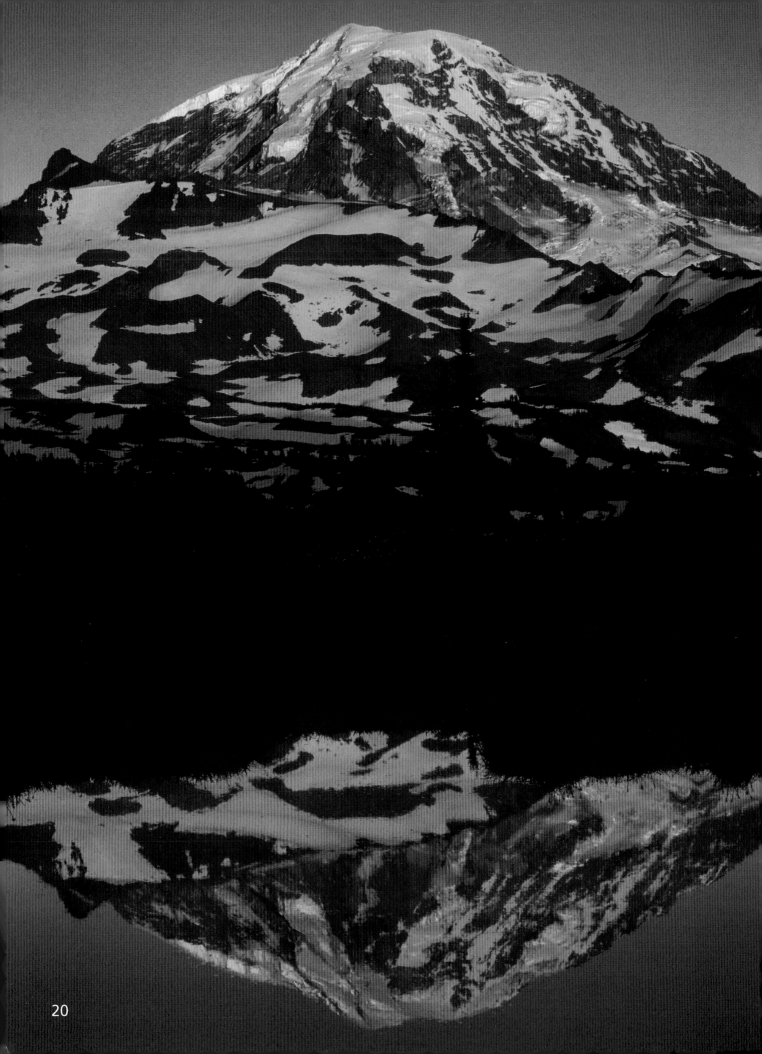

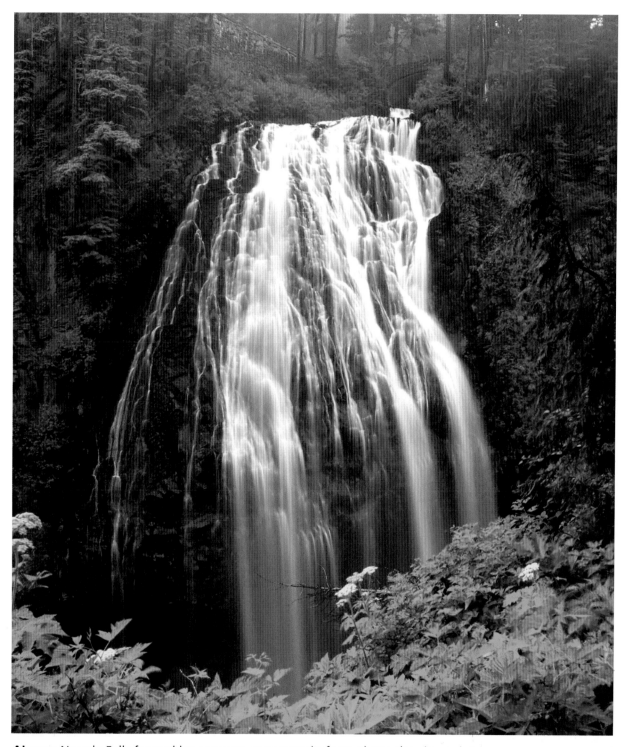

Above: Narada Falls framed by common cow parsnip from above the viewpoint.

Opposite: Brilliant evening alpenglow on Mount Rainier reflected in a tarn in Spray Park at sunset.

Waterfalls

The most glaciated mountain in the lower forty-eight states cannot be without its share of waterfalls. In fact, Mount Rainier National Park is famous for its many beautiful waterfalls.

The most popular waterfalls reside on the south side of the park. Here one can capture the famous shot of Christine Falls framed by the stone bridge of the Paradise Road, or drive a little further to the viewpoint of the Paradise River cascading over Narada Falls.

From the Paradise parking lot, it is only a short walk along the Skyline trail to Myrtle Falls.

A fairly steep 1.5-mile hike will reward photographers with a view of the 320-foot plunge of Van Trump Creek over Comet Falls — a truly spectacular show.

The north side of the park may not equal the number of waterfalls as the south, but that is not to say they are any less beautiful. Spray Falls may be one of the prettiest waterfalls in the entire park and is only a 2-mile walk from Lake Mowich along the Spray Park trail.

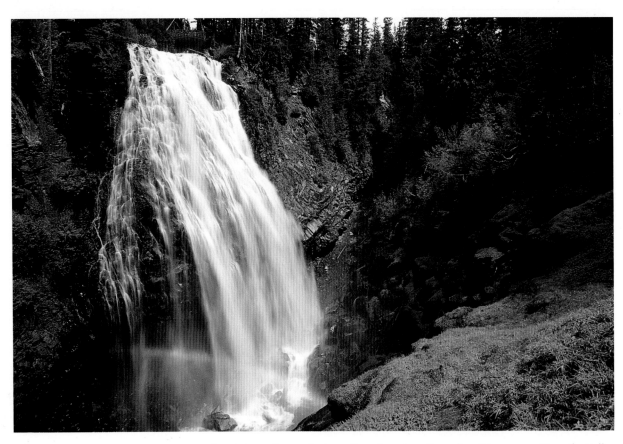

A rainbow forms below the plunging Paradise River over Narada Falls.
Opposite Page: Spray Falls.

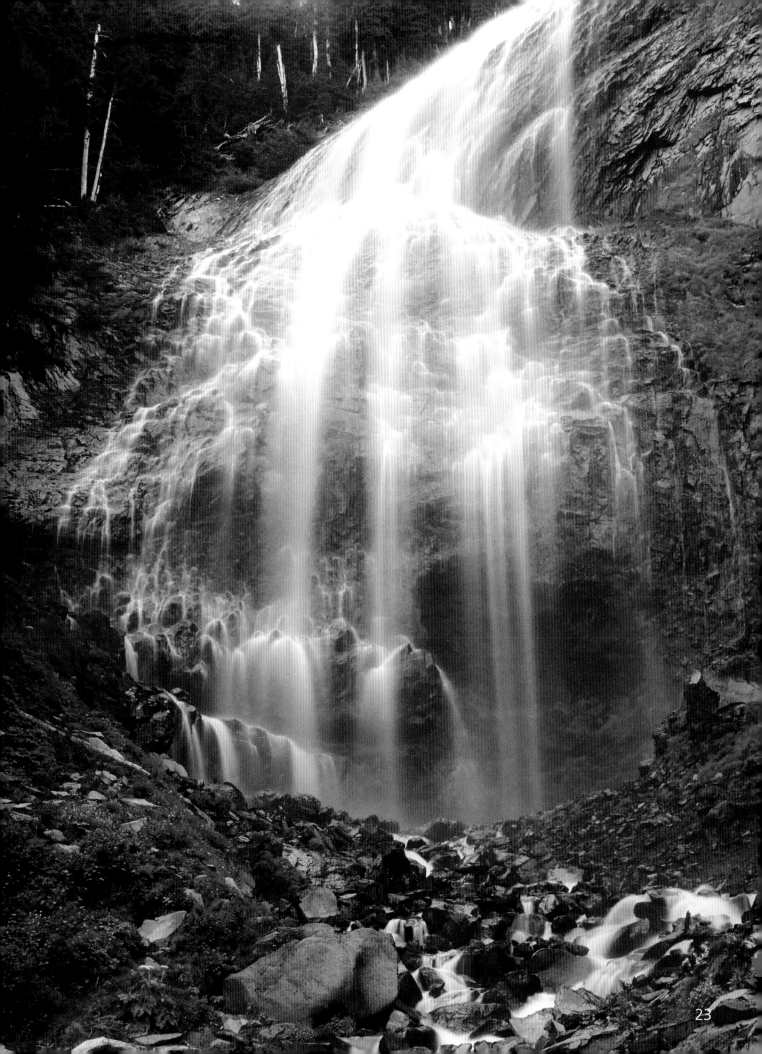

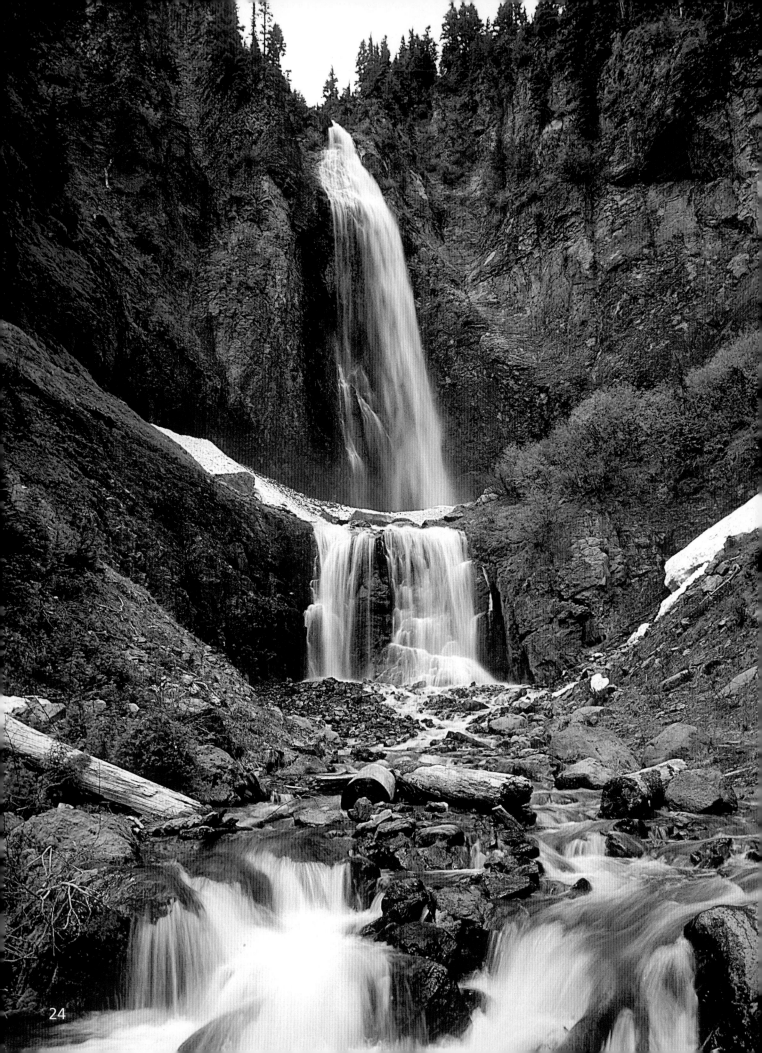

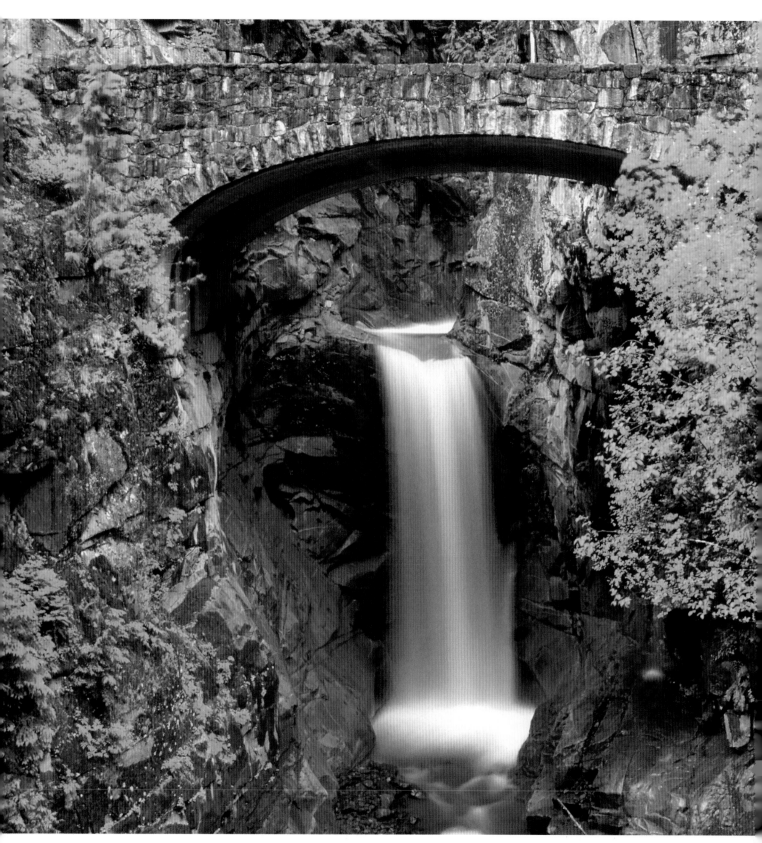

Above: Van Trump Creek pours soothingly over Christine Falls.

Opposite page: Van Trump Creek plunges 320 feet over Comet Falls.

Late Summer

By mid-August almost all of the high trails in Mount Rainier National Park are usually accessible, creating a world of opportunities for the ambitious photographer. Wildflowers begin to fade, and so do the bugs. Early September brings cool evenings and hints that fall is just around the corner. Streams run lower and many tarns begin to dry up. Days are shorter and nights are longer, greatly helping the photographer who stays up to shoot sunset, only to wake early for sunrise.

There are many great vantage points from which to witness sunrise and sunset on Mount Rainier, both inside and outside the park.

For sunrise, one should position themselves on the eastern side of the park. At sunrise, the Silver Forest trail and Sourdough trail offer excellent vantages of the brilliant pink alpenglow that often radiates from the Emmons Glacier. The energetic person can don headlamp and scurry up Burroughs Mountain or get high up on the Fremont Lookout trail.

The Tipsoo Lake area and the Naches Peak trail are excellent places to photograph sunrise on the mountain. This is also a prime area for fall colors in October, but let's save that for later.

The Paradise area also provides a very nice opportunity to catch sunrise. The Skyline trail and Reflection Lakes are popular. Other favorites are Pinnacle Saddle and Bench Lake. For climbers with proper training, Pinnacle Peak offers a grand viewpoint and is quickly attainable from the road.

Sunset is best viewed from the western flanks of the park — and outside the park. Glacier View in the Glacier View Wilderness just outside the Nisqually Entrance offers a grand seat for evening light with modest effort. Views are similar to those of Gobblers Knob inside the park, but with much less effort. What's more, you can get a preview of conditions on your drive up FS Road #59. This might be the most scenic side of the mountain with the rock wall above the Tahoma Glacier making up Sunset Amphitheater.

Despite the increase in effort to view evening light on the mountain from several destinations up the West Side Road, they still must be mentioned (think mountain bike!). Gobblers Knob is probably the best and offers comfort from the wind on the deck of the lookout.

Further up the West Side Road is Klapatchie Park where sunset can be captured in the waters of Aurora Lake. Just a short distance south along the Wonderland Trail is St. Andrews Park and St. Andrews Lake.

On the northwest side of the mountain, the Clearwater Wilderness offers two

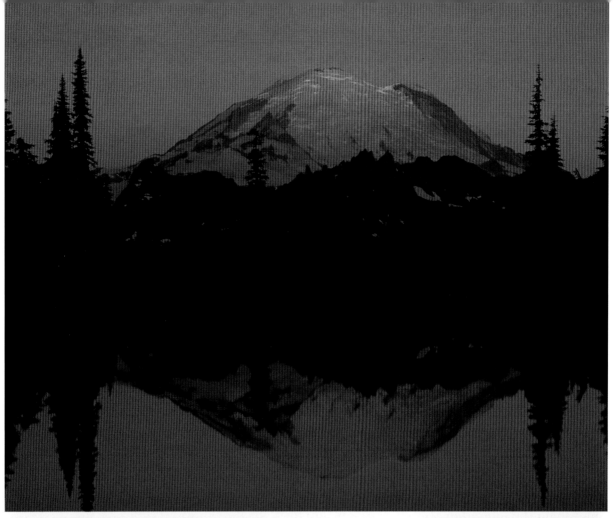

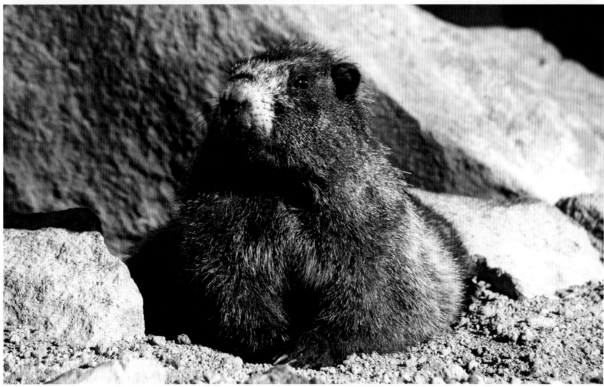

Above: Morning alpenglow on Mount Rainier and the Emmons Glacier reflected in calm waters near Tipsoo Lake.

Below: Hoary marmot

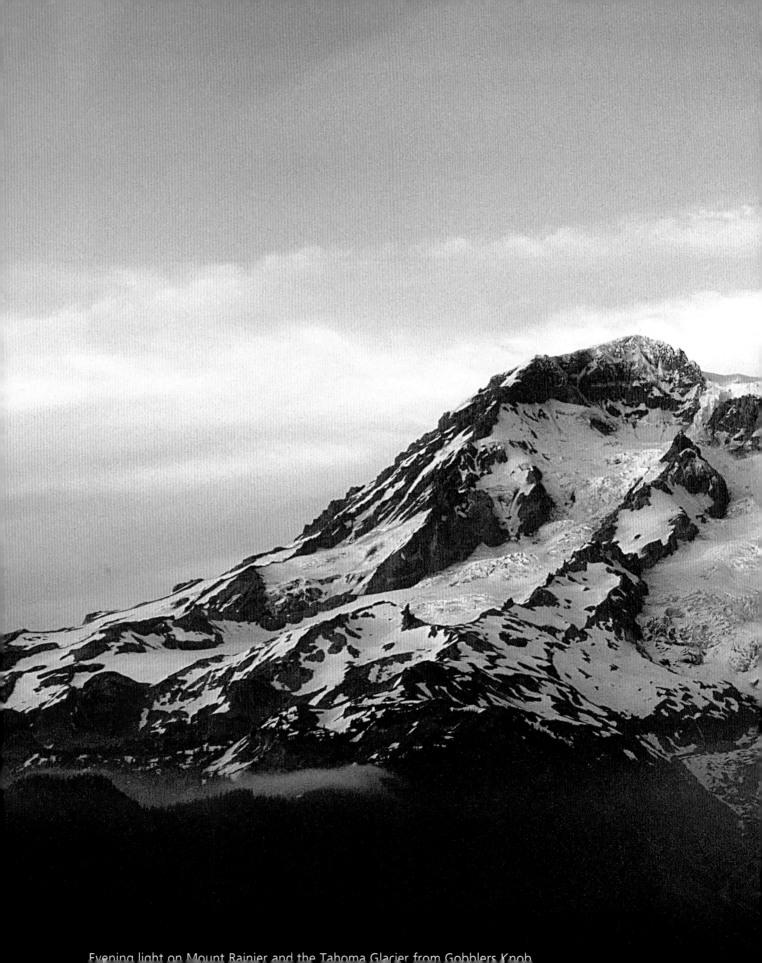

Evening light on Mount Rainier and the Tahoma Glacier from Gobblers Knob

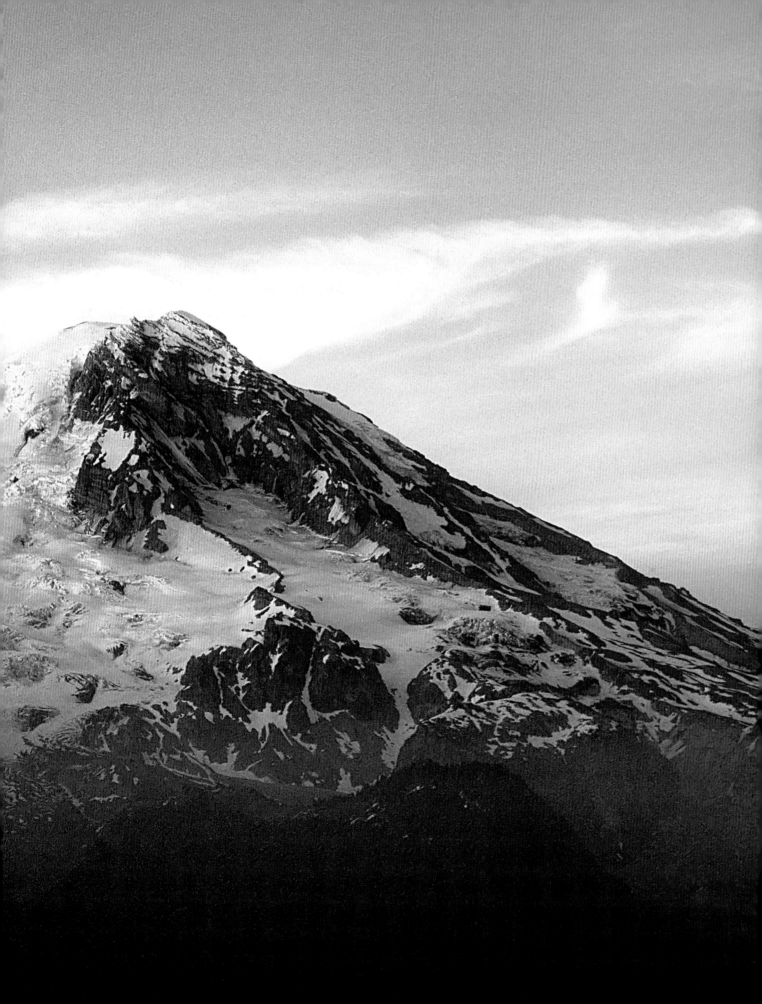

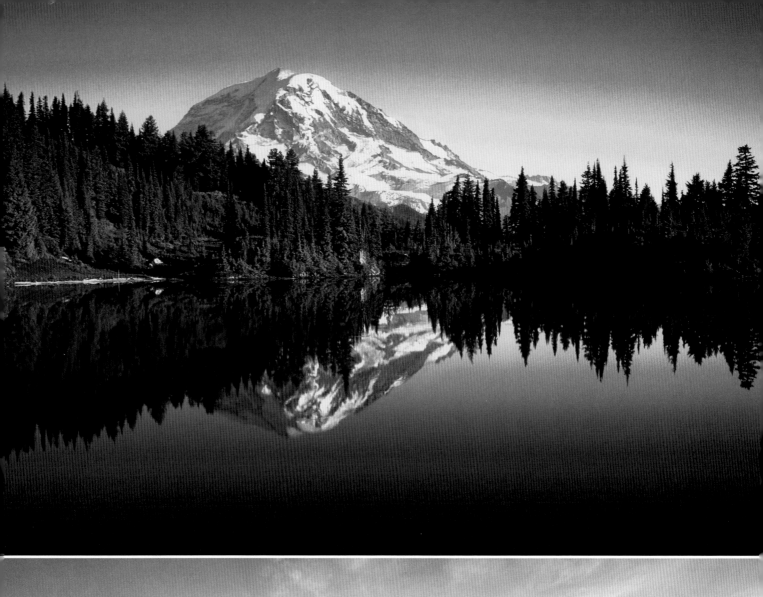

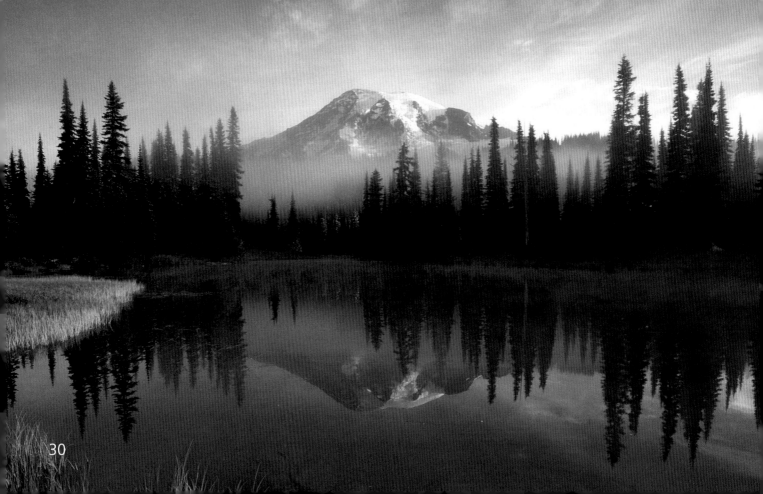

excellent viewpoints: one on a knoll above the waters of Summit Lake, the other from the summit of Bearhead Mountain. Both share the same trailhead, located just outside the Carbon River Entrance up FS Road #7810.

Inside the park, Eunice Lake and Tolmie Peak offer excellent vantages with little effort. One can walk around Eunice Lake to a point below Tolmie Peak for an excellent reflection shot, or continue one mile further up the trail to the lookout tower for an unobstructed view. For the ambitious backpacker, Moraine Park must once again be mentioned. The best views of sunset are along the side trail leaving the Wonderland Trail at the pass above Moraine Park and following the climber's trail along Curtis Ridge; that is, if one can get past the classic tarn reflection.

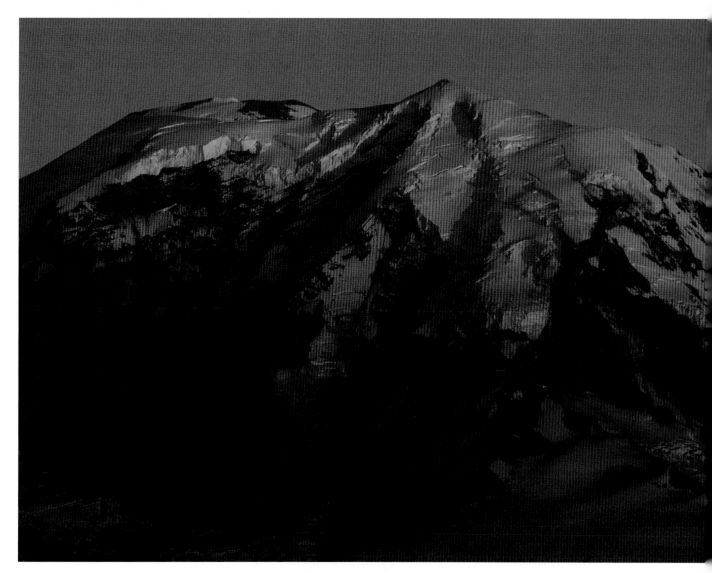

Above: Evening alpenglow strikes Liberty Cap, Ptarmigan Ridge and the Willis Wall on Mount Rainier. Photographed from a knoll above Summit Lake in the Clearwater Wilderness.

Opposite top: Mount Rainier reflected in the deep blue waters of Eunice Lake below Tolmie Peak.

Opposite bottom: Reflection Lakes captures the reflection of Mount Rainier emerging above a layer of morning fog. The mountain had only appeared shortly before this image was taken.

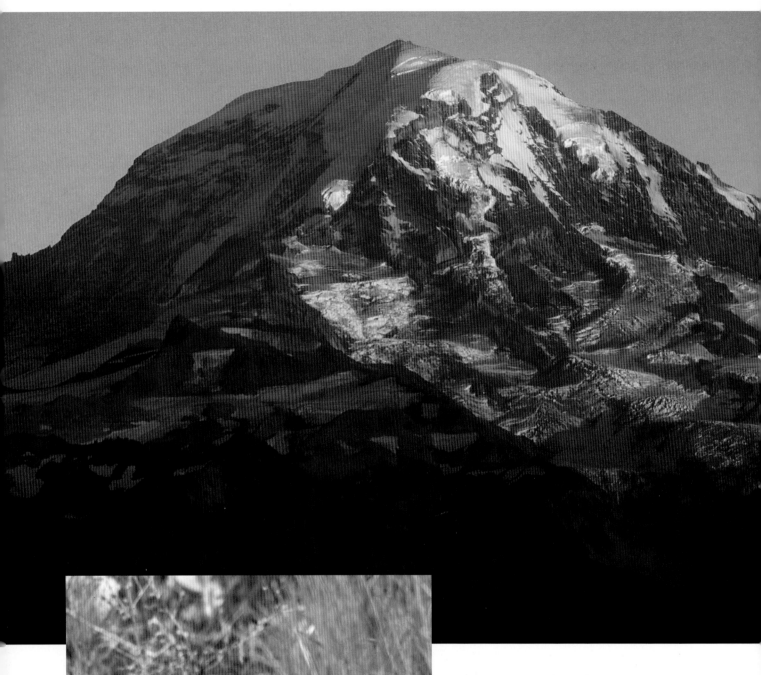

Above: Evening alpenglow on Mount Rainier from the summit of Tolmie Peak.

Left: A female blue grouse hides by sitting still camouflage out in the open.

Opposite top: Evening light on Mount Rainier above low valley clouds from Glacier View in the Glacier View Wilderness.

Opposite bottom: Mount Rainier above grass meadows in Yakima Park above Sunrise.

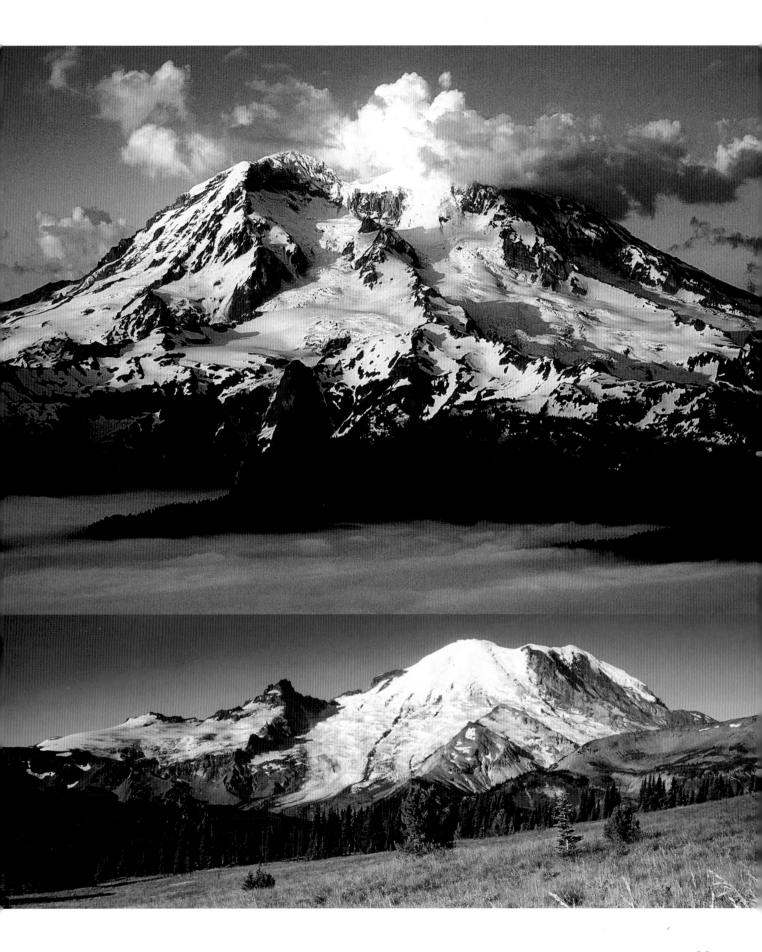

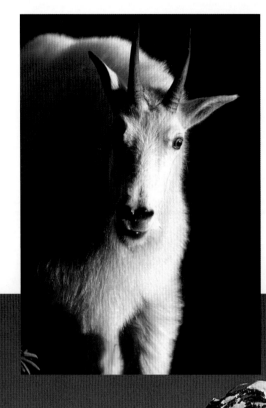

A curious mountain goat.

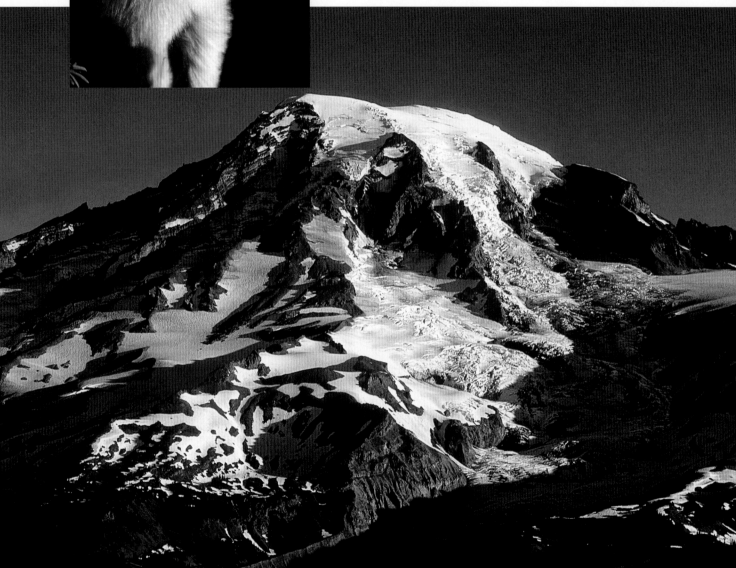

Above: Mount Rainier from the summit of Pinnacle Peak in the Tatoosh Range.

Opposite: Evening light on Mount Rainier and the Willis Wall reflected in a tarn above Moraine Park.

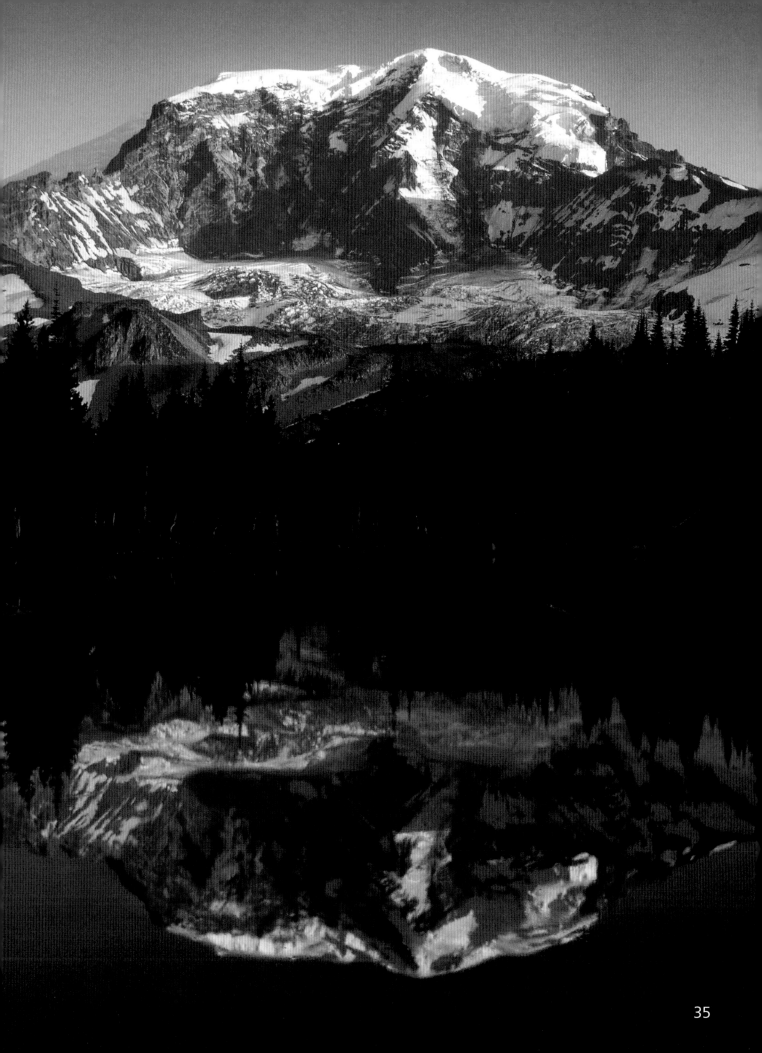

High on the Mountain

A book focused on photographing Mount Rainier National Park would be incomplete without addressing the possibilities awaiting the extremely motivated photographer who can attain its upper slopes and, hopefully, its summit.

Climbers are humbled and awed by the extremes of nature that ocur at these higher elevations. Here the world changes to one of ice and desolation. Meadows succumb to amazing rivers of ice. Crevasses are large enough to swallow entire buildings and seracs over a hundred feet high are capable of toppling at any moment. Yet, Rainier's upper slopes can be as beautiful as anything the park has to offer below. Some of the most amazing sunrises and sunsets I have ever seen have been from these heights.

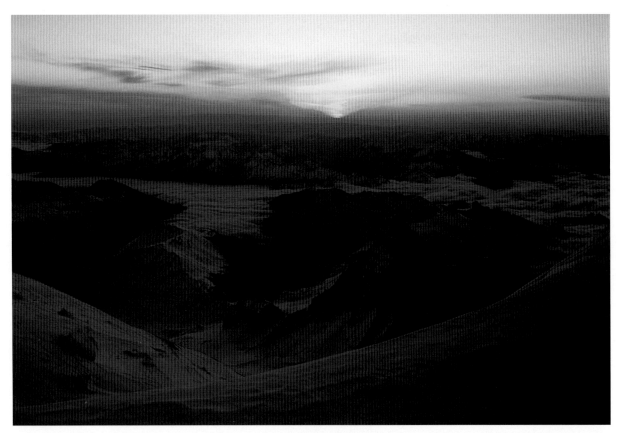

Above: Sunrise above a sea of valley clouds from 12,500 feet on the Ingraham Glacier.

Opposite top: A climber traverses below Steamboat Prow near Camp Schurman at 9,500 feet.

Opposite bottom: Darrell Geyer climbing high on the Winthrop Glacier.

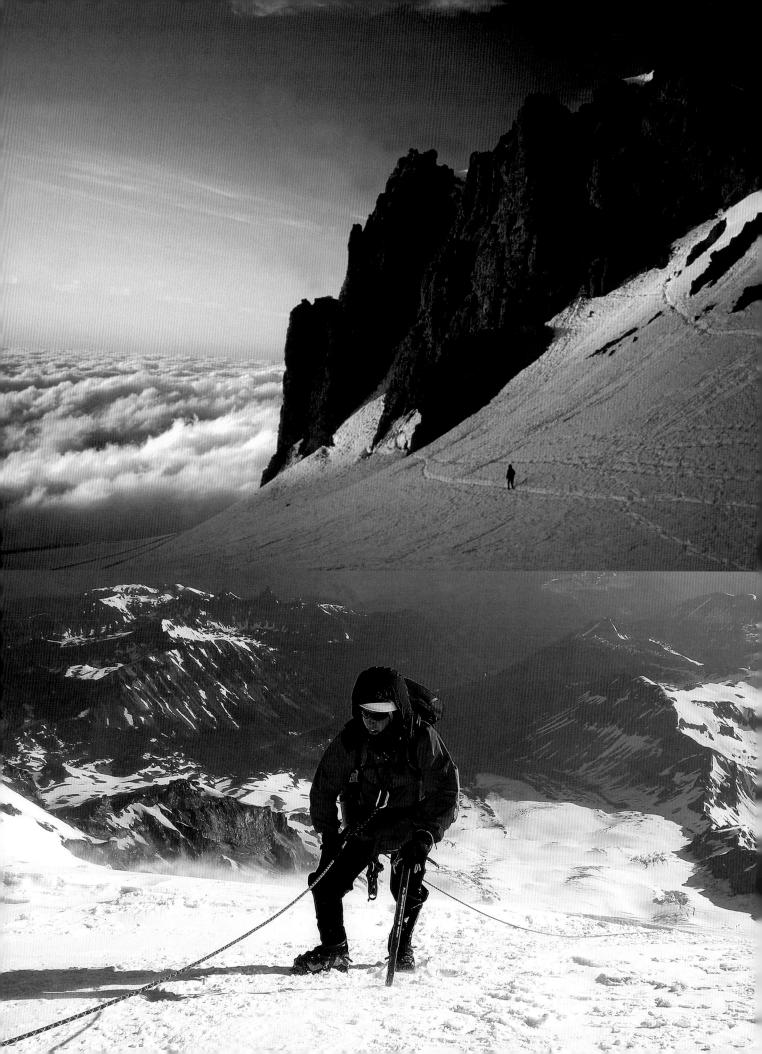

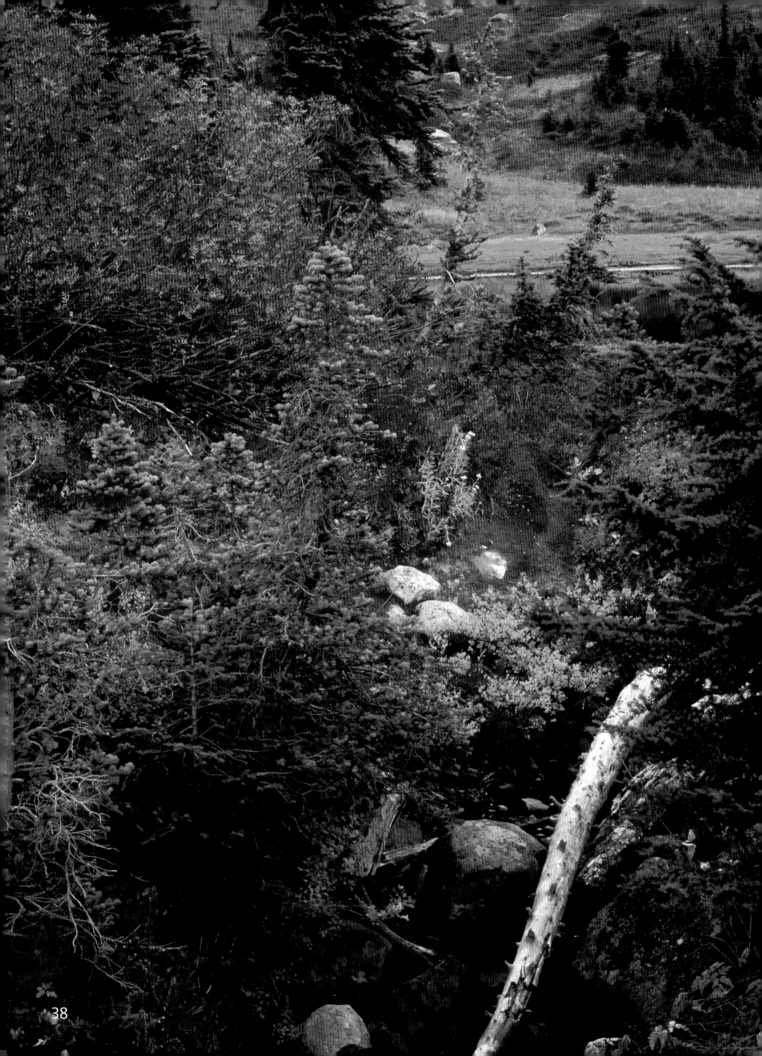

Autumn

Autumn is probably my favorite season to photograph. The colors are just so vivid and tend to jump out to you in all their grandeur. There is a cool nip in the air that I find entirely refreshing and invigorating.

Most people associate Mount Rainier National Park with intense flower meadows, but not many are aware of the incredibly vibrant autumn foliage it has to offer. Though these reds, yellows and oranges serve as excellent supporting casts for primary subject matter such as Mount Rainier, diffused light offers the opportunity create many interesting compositions on the strength of the radiant foliage alone, possibly coupled with one or two contrasting elements. Polarizers and warming filters will help these colors pop out even further in such conditions.

Autumn is my favorite time of the year to visit Indian Henry's Hunting Ground. The open meadows attract full sun throughout the year, a definite prerequisite to the turning of huckleberry foliage in the fall. Colors are excellent from the top of Mount Ararat, through the meadows near the patrol cabin and past the shores of Mirror Lake — the most popular and photogenic destination of this parkland.

In the Carbon River/Mowich Lake area there are two excellent choices for fall foliage: Ipsut Pass and Knapsack Pass. Both should be approached from Mowich Lake. (Ipsut Pass can be hiked to from Carbon River.) For Ipsut Pass, the best colors are just below the pass in an upper basin.

Knapsack Pass is an unofficial trail that begins just past the Mowich Ranger Station. Its upper basin turns a brilliant red in the autumn season and can be witnessed above Lake Mowich from the parking lot.

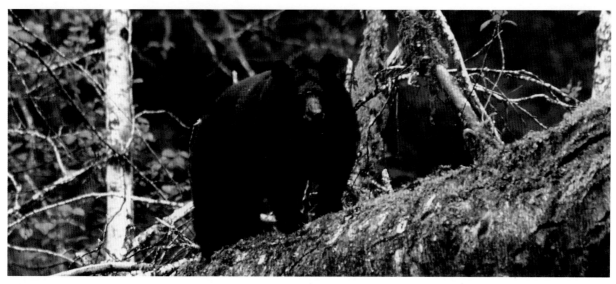

Above: A mother black bear stands watch on a log above her cubs.

Opposite: Fall colors above Tipsoo Lake near Chinook Pass.

For the best the park has to offer, one must travel to the east side of the park. Prime destinations on the northwest side of the park are Tipsoo Lakes and the Naches Peak Loop. Tipsoo Lakes offer photo opportunities right from the road, while the Naches Peak Loop will require one to stretch their feet a little.

The southwest side of the park is likely the very best that the park has to offer. There are numerous destinations both easy and challenging that pay out great rewards. Colors begin just inside the Ohanapecosh entrance and build all the way up to the Paradise parking lot.

The Bench and Snow Lake trail delivers the photographer to meadows of autumn foliage with minimal effort, with supreme views of sunrise on Mount Rainier as a bonus. One can continue on to Bench Lake to catch the reflection of morning alpenglow on the mountain.

The Lakes trail begins to the east of the smallest of the Reflection Lakes. No signs needed. The colors near Reflection Lakes are absolutely vibrant and the scenery will certainly enthrall the photographer. The Lakes trail will enhance the experience by taking the photographer past many subalpine tarns with shores lined with red. Reflection compositions are endless. One may continue this trail all the way to its junction with the Skyline trail, where views of Mount Rainier may be had.

The Pinnacle Saddle trail leaves from the larger of the two Reflection Lakes and on the opposite side of the road. It definitely finds itself a beneficiary to everything this entire area has to offer, complete with views back to the mountain.

Last but not least, one will arrive at the Paradise parking lot looking up at the contrast of reds and greens of Paradise Meadows below Mount Rainier. Excellent opportunities present themselves along every trail, though typically staying lower is better.

Above and Opposite: Autumn colors line The Lakes trail near Reflection Lakes.

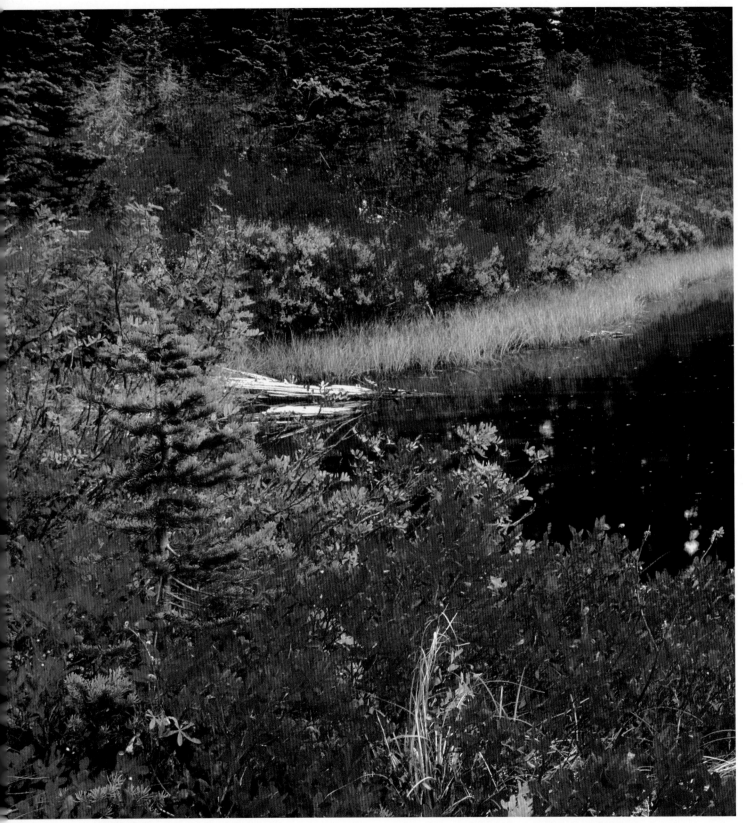

Above: The shores around a tarn along The Lakes trail are blanketed with red autumn foliage.

Right Top: Mount Rainier above autumn colors in Paradise Meadows.

Right Bottom: Mount Rainier above autumn colors along the Snow Lake trail.

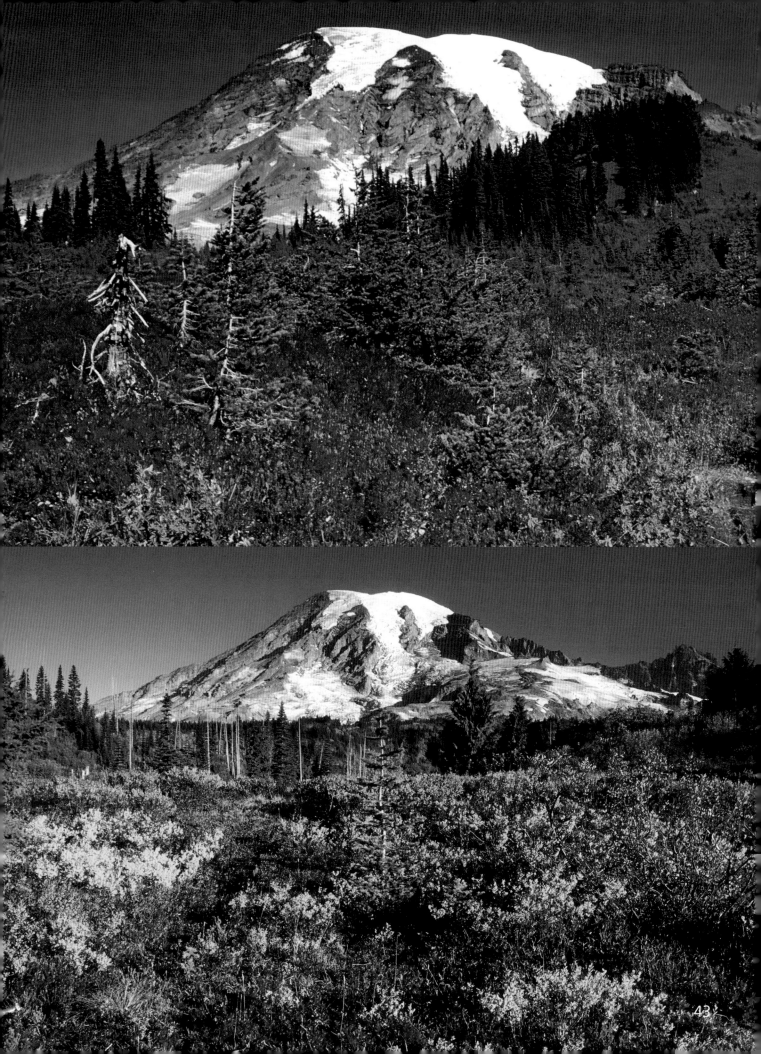

Winter

Mount Rainier National Park offers excellent opportunities for photography during the winter months, especially for skiers and snowshoe enthusiasts ambitious enough to spend time in the backcountry. The rewards are more than worth the effort expended.

Access to various parts of the park becomes restricted during the winter months due to road closures. Lost are the Sunrise Entrance, the eastside of the park and the Stevens Canyon Road. The West Side Road and the Mowich Lake Road must be walked (or skied).

The Nisqually Entrance is by far the most popular entrance to the park in the winter months, providing access to the West Side Road, Longmire and Paradise.

Reflection Lakes is one of the easiest trips, beginning from either the Paradise parking lot or the Narada Falls parking lot (shorter). It is mostly a road walk, though a detour might be necessary during periods of increased avalanche danger via The Lakes trail. From Reflection Lakes, a more ambitious outing may begin by climbing up toward Castle Peak in the Tatoosh Range. This is a very popular trip amongst backcountry skiers.

The Paradise parking lot attracts the most people in the winter months, offering trips as easy or difficult as one wishes to attempt. Many organized groups practice winter camping in this area and it is not uncommon to see groups of tents scattered about throughout Paradise Park. Up above are Alta Vista, Panorama Point, and of course Camp Muir. The views get better and better the higher you climb.

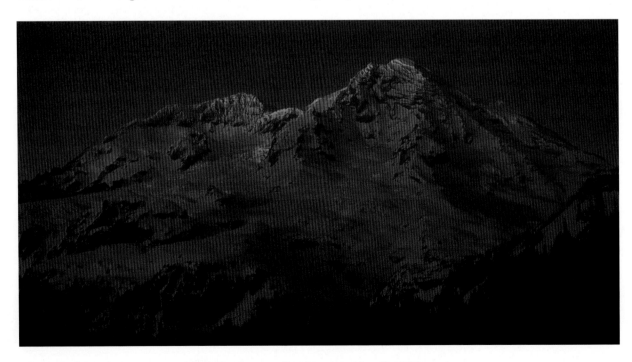

Evening alpenglow on Mount Rainier from Indian Henry's Hunting Ground.

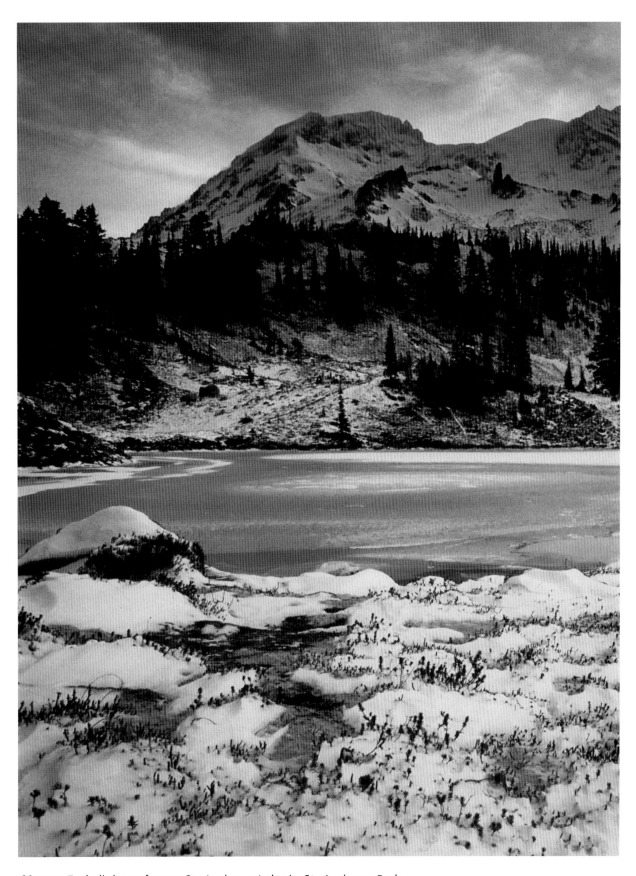

Above: Early light at frozen St. Andrews Lake in St. Andrews Park.

Next Page: Sunrise over Mount Rainier above Aurora Lake in Klapatchie Park.

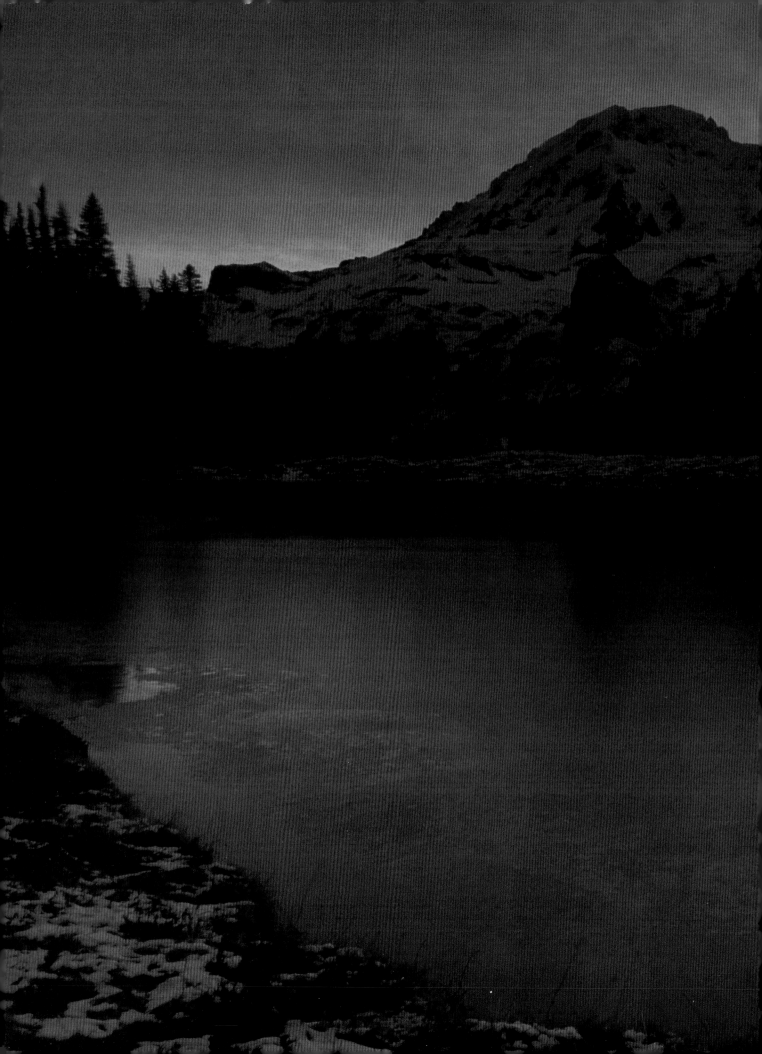

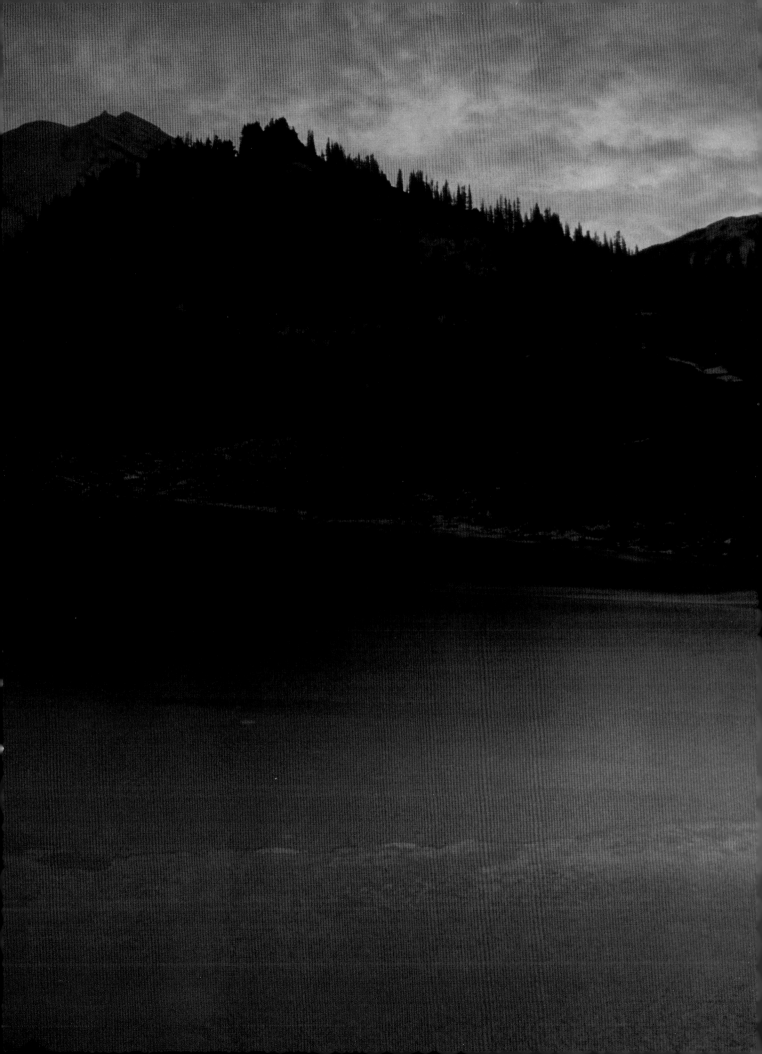

Other great **HANCOCK HOUSE** *natural history titles*

Bears of the North
Steven Kazlowski
ISBN: 0-88839-591-4
8.5" x 11", softcover
48 pages

Wildlife of the North
Steven Kazlowski
ISBN: 0-88839-590-6
8.5" x 11", softcover
48 pages

Rocky Mountain Wildlife
Brian Wolitski
& David Hancock
ISBN: 0-88839-567-1
8.5" x 11", softcover
80 pages

The Mountain Grizzly
Michael S. Quinton
ISBN: 0-88839-417-9
8.5" x 11", softcover
64 pages

White Spirit Bear
Grandma Tess
ISBN: 0-88839-475-6
8.5" x 11", softcover
48 pages

View all **HANCOCK HOUSE**
titles at www.hancockhouse.com